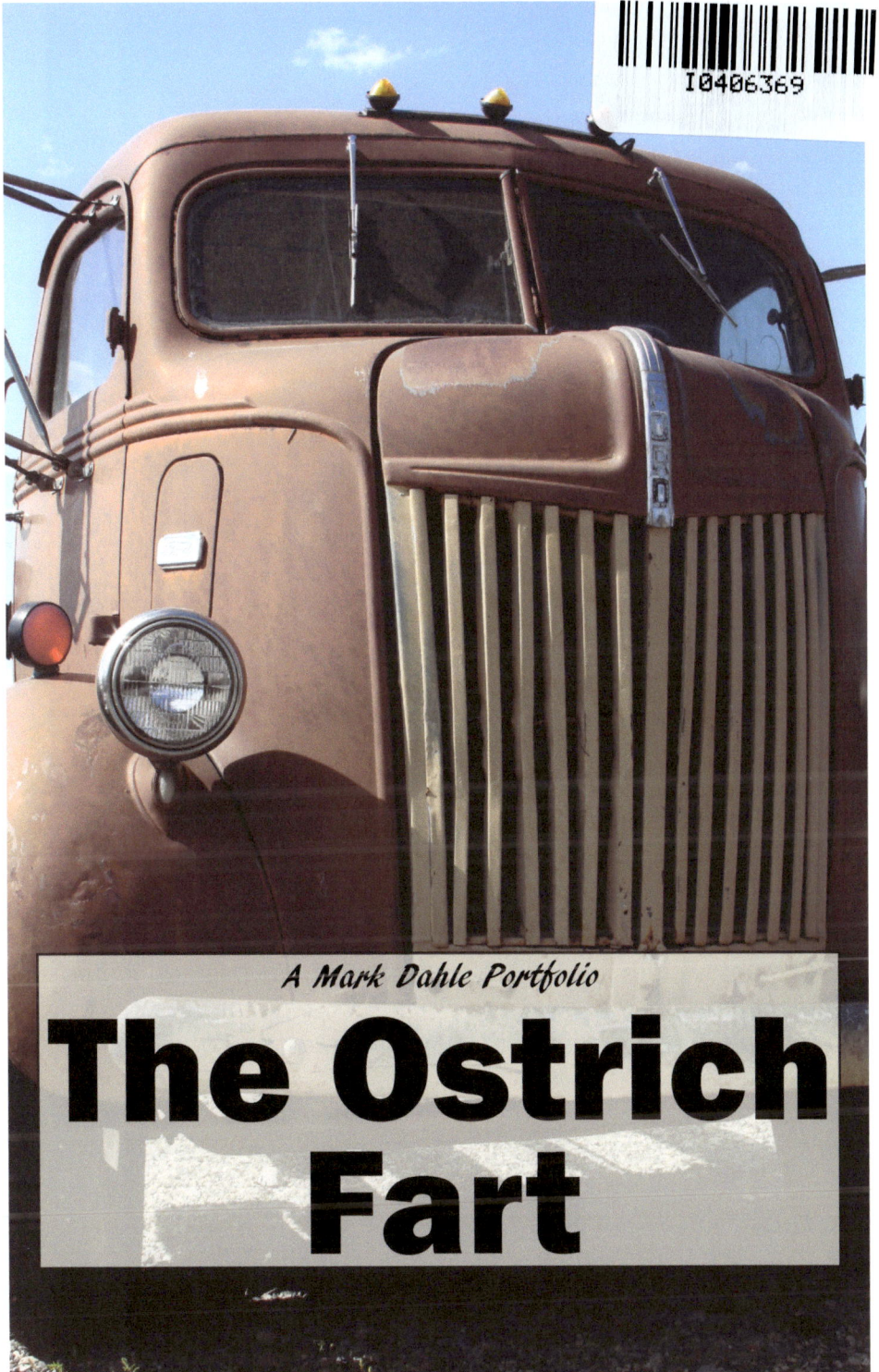

A Mark Dahle Portfolio

The Ostrich Fart

For Jeremiah, when he was six.

~ ~ ~

Mark Dahle Portfolios can be read in a few minutes and enjoyed for a lifetime.

Unlike many picture books, the text in this portfolio is not related to the photographs of beautiful cars, trucks and motorcycles or to the painting at the right. This may disappoint first graders, for whom this book is written. Luckily there is lots of space for them to draw their own pictures of gorilla poo, if their mothers let them.

Photographs in this book are available in limited editions.
See http://www.MarkDahle.com for more information
and for previews of upcoming portfolios.

© Mark Dahle 2013. All rights reserved.

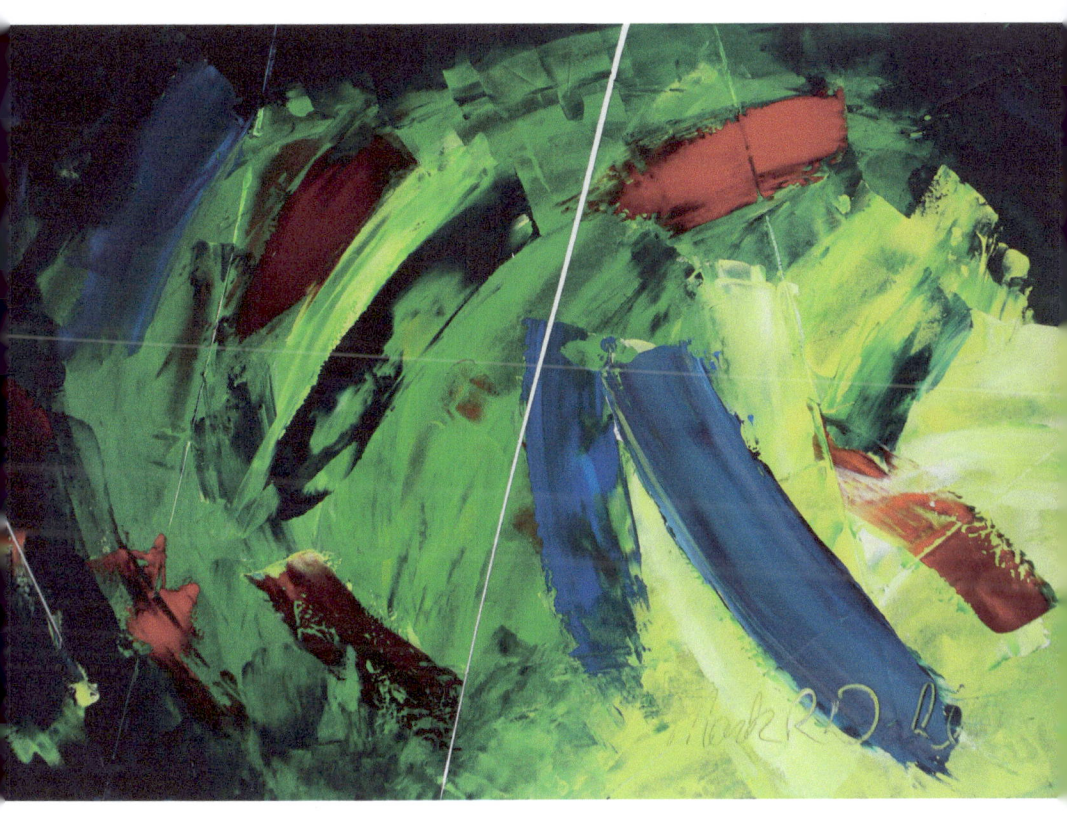

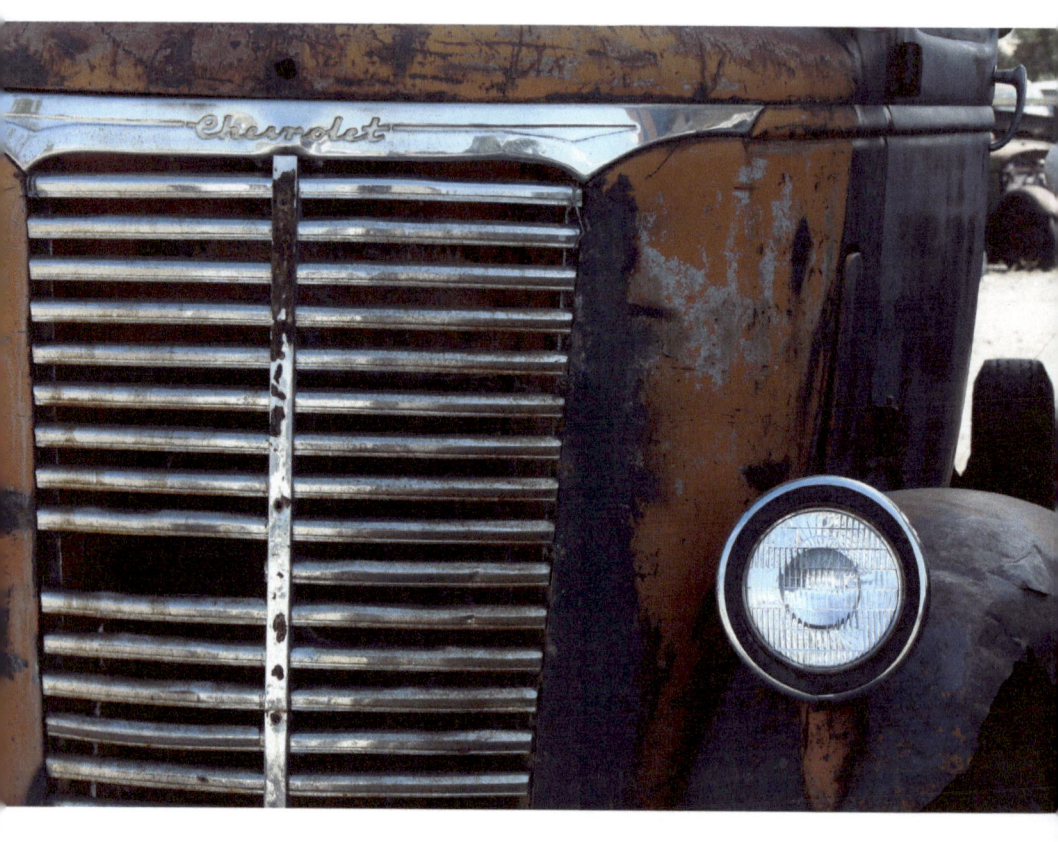

Miss Crunzle *insisted*
that everyone
in her First Grade class
be perfectly dressed.

When Jim came to school
and his t-shirt wasn't tucked in,
Miss Crunzle sent him home
to get it fixed.

That's how strict she was.

One cold day
Miss Crunzle took everyone
to the zoo.

She wanted her class to see
how nice the monkeys looked
after spending all day grooming.

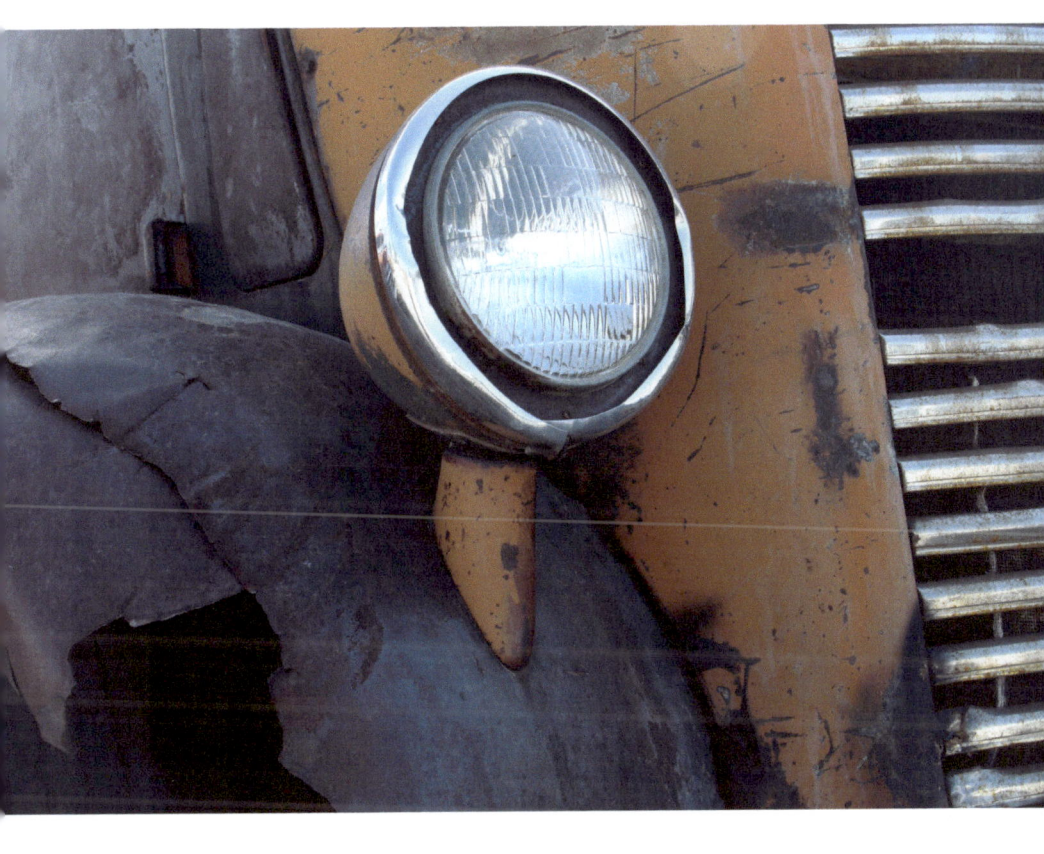

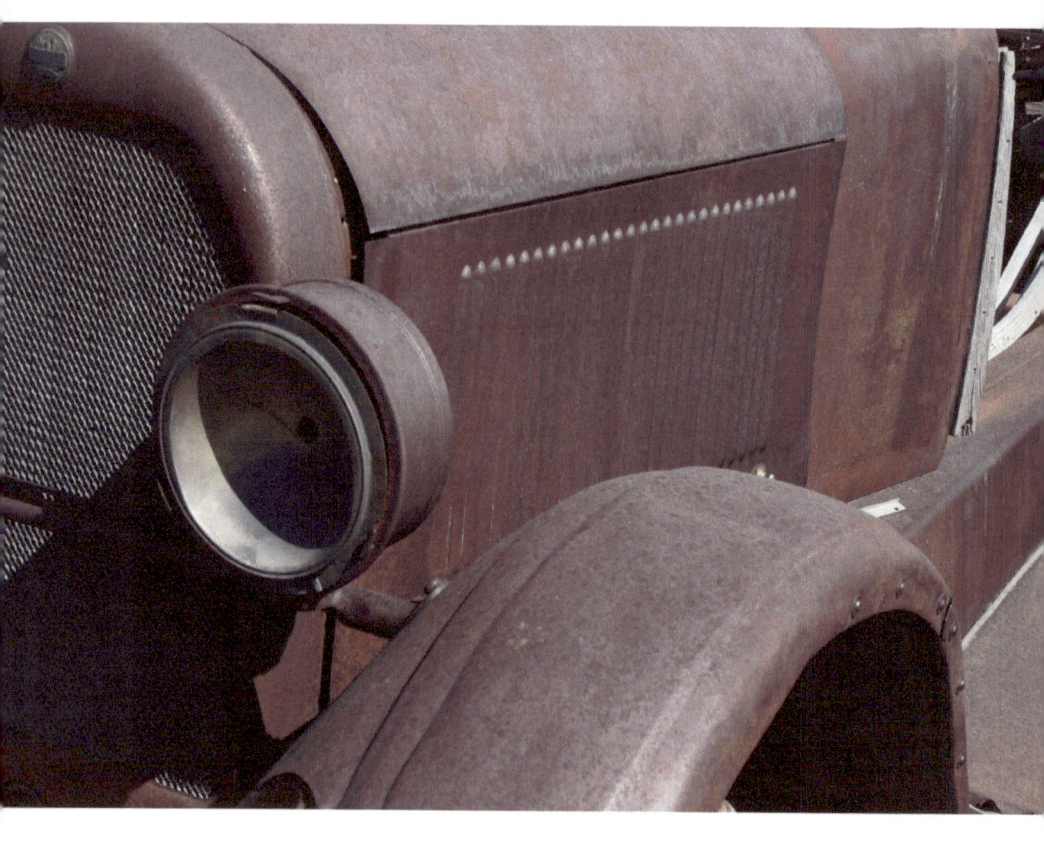

When Miss Crunzle's class arrived,
the ostrich had been trying for hours
to be as lady-like
as the flamingos.

She was standing on one foot
and trying to look as pink as possible
when the stress of it all
caused her to fart.

It was not the sort of thing
that pink flamingos do.

And it was quite a bit louder
than a flamingo fart.

Way louder.

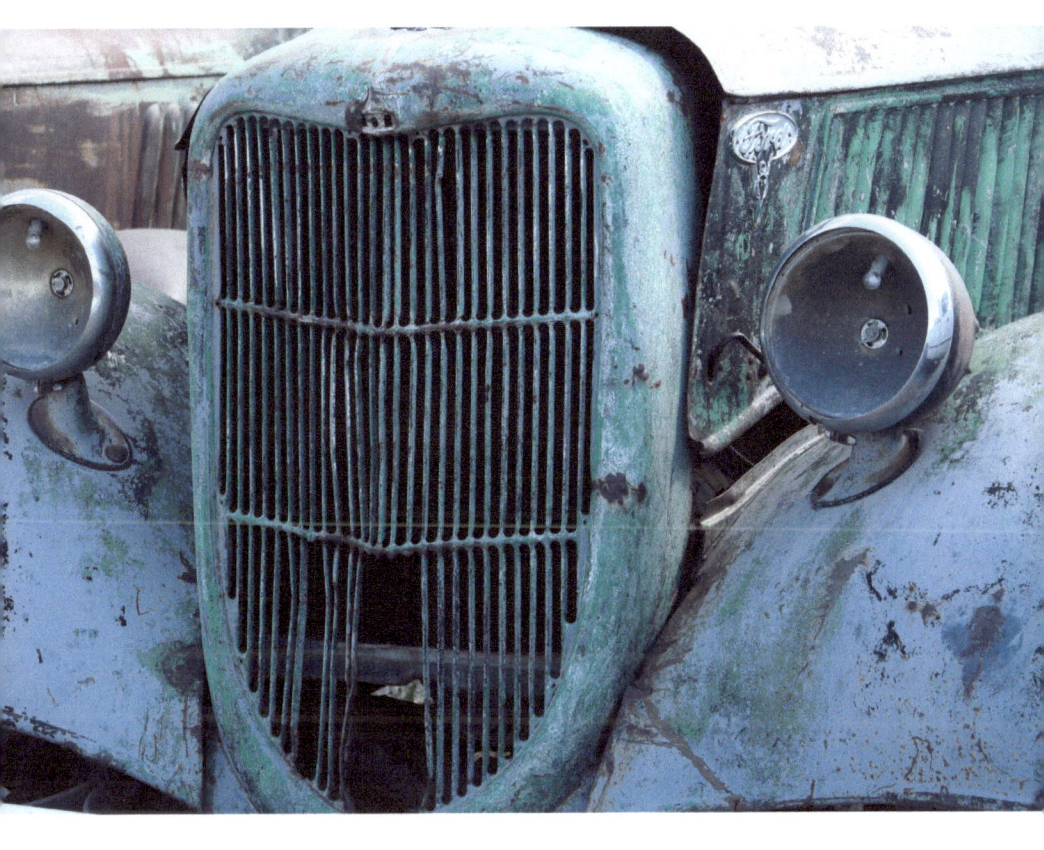

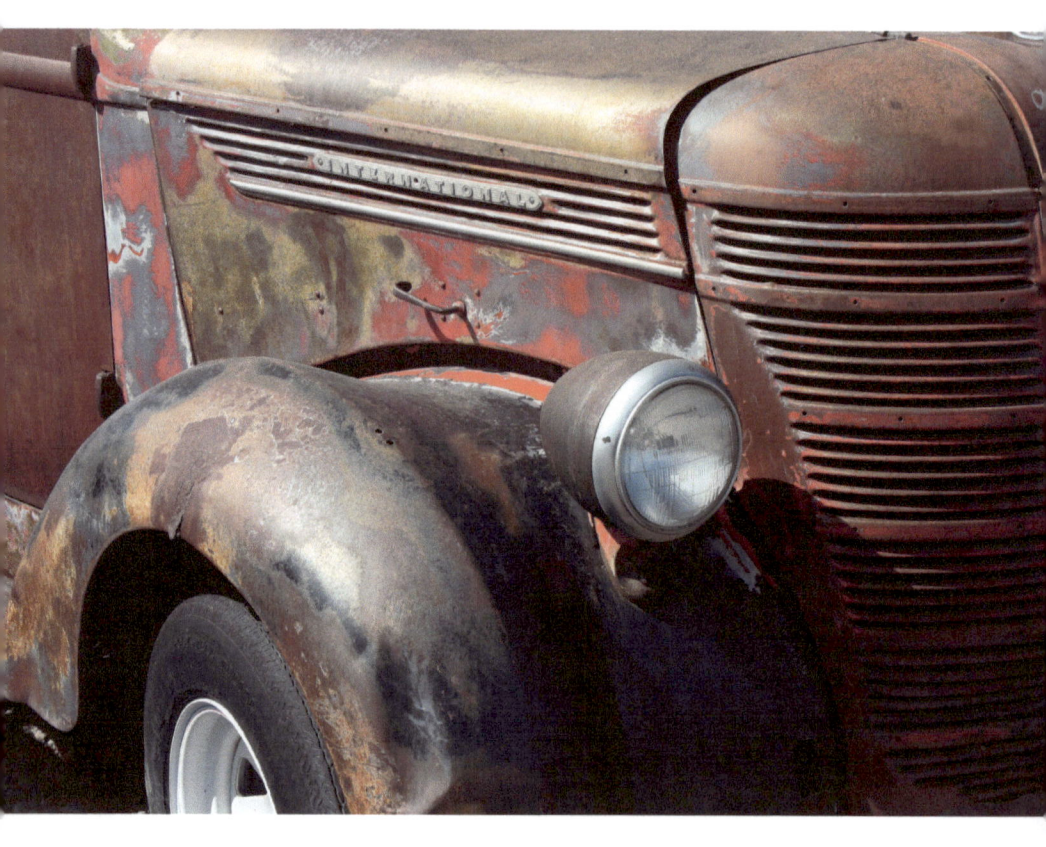

The ostrich was so embarrassed by this
that she put her head down
and pretended
to turn some eggs
in her nest.

That caused her butt
to be about nose high
when the rhinoceros walked past
and she tooted again.

In his face.

The rhino had poor eyesight.

He thought he was walking up
to a short tree
that he might want to nibble.

He got his nose
as close to the tree as he could
and was just taking a deep breath
so he could smell what *kind* of tree it was,
when it happened.

The rhino got a BIG whiff
of ostrich fart.

It smelled so bad
and surprised the rhino so much
that he tooted himself.

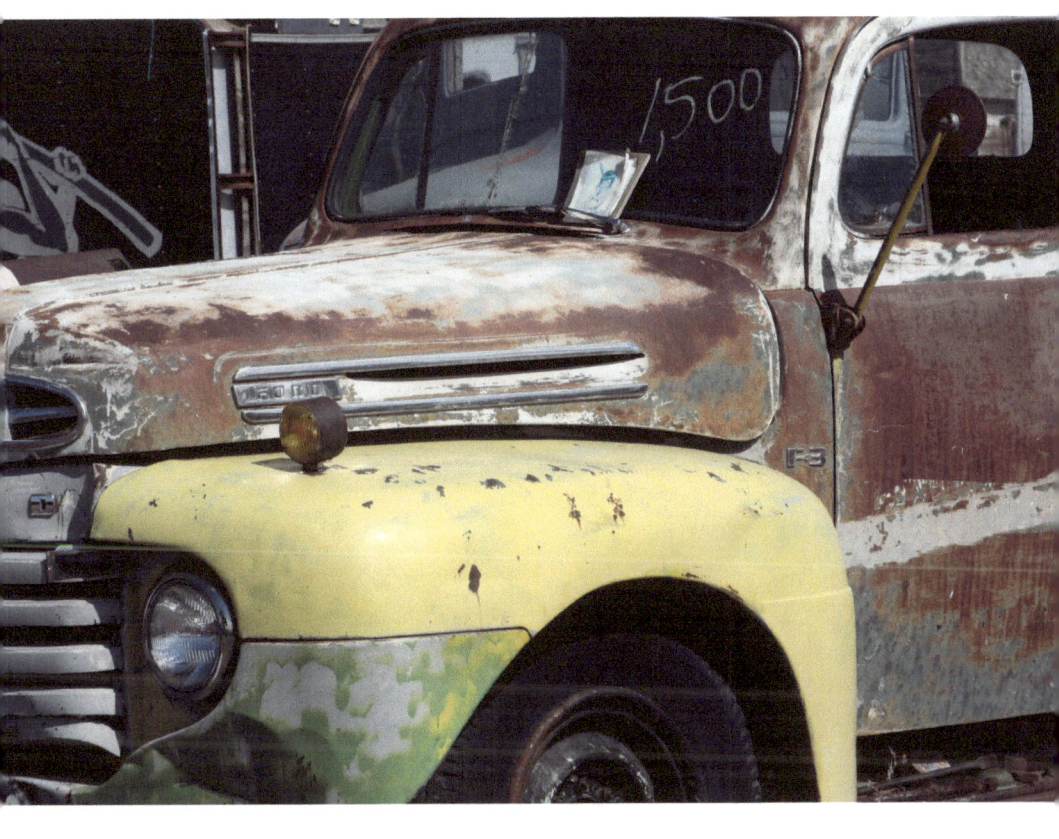

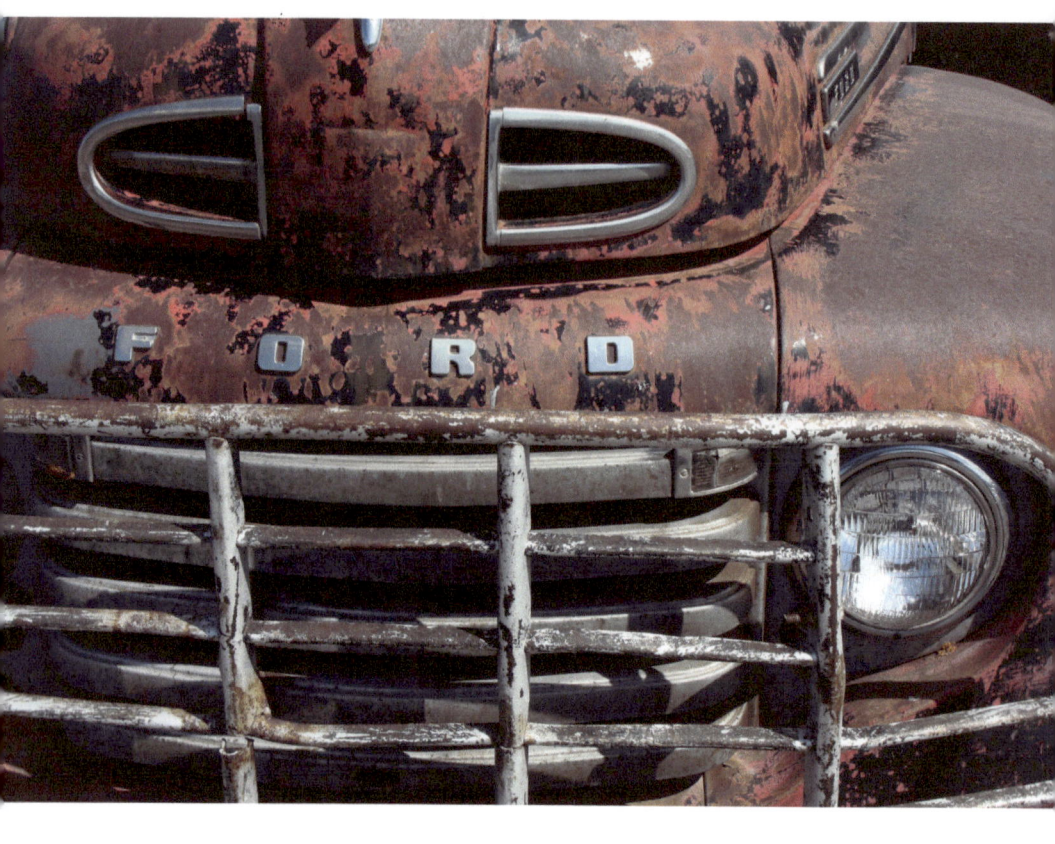

An ostrich fart is loud,
but it is nothing
compared to the blast
of a 4,000-pound rhino.

All the spider monkeys started laughing
when they heard the explosion.

The rhino was not used
to smelling big gulps of ostrich fart
and he was not used
to tooting in public
and he was NOT used
to being laughed at
by spider monkeys.

He broke into a run to get away.

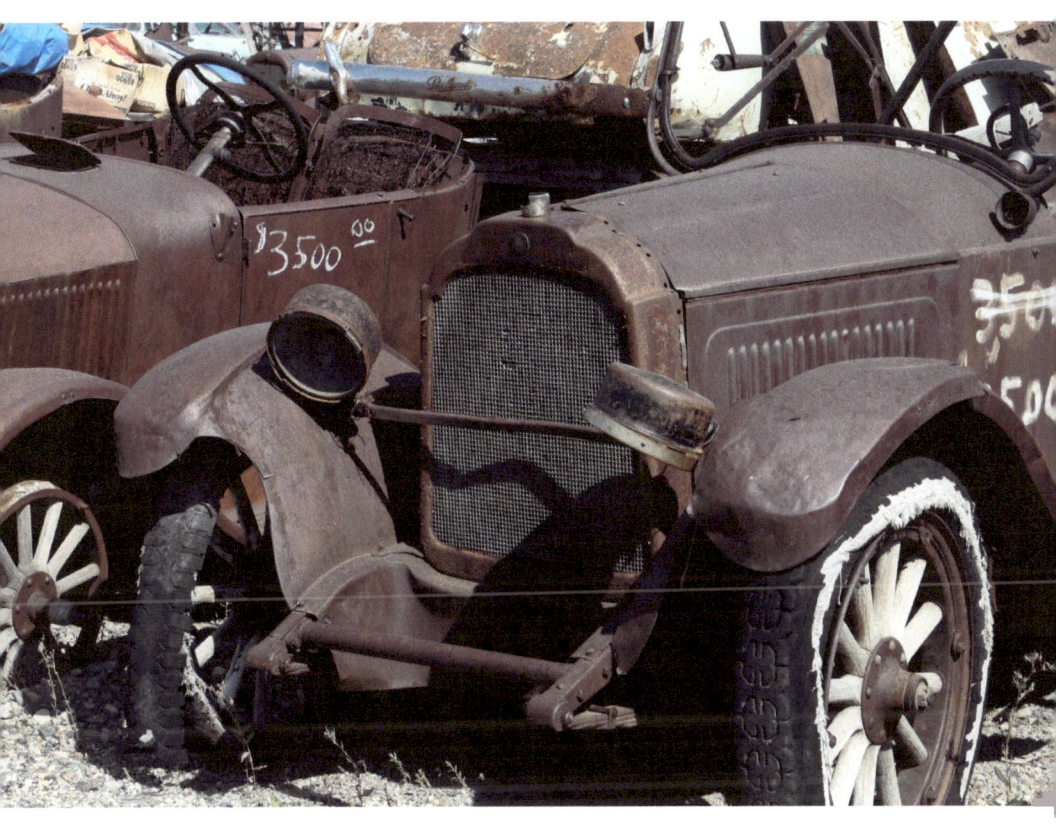

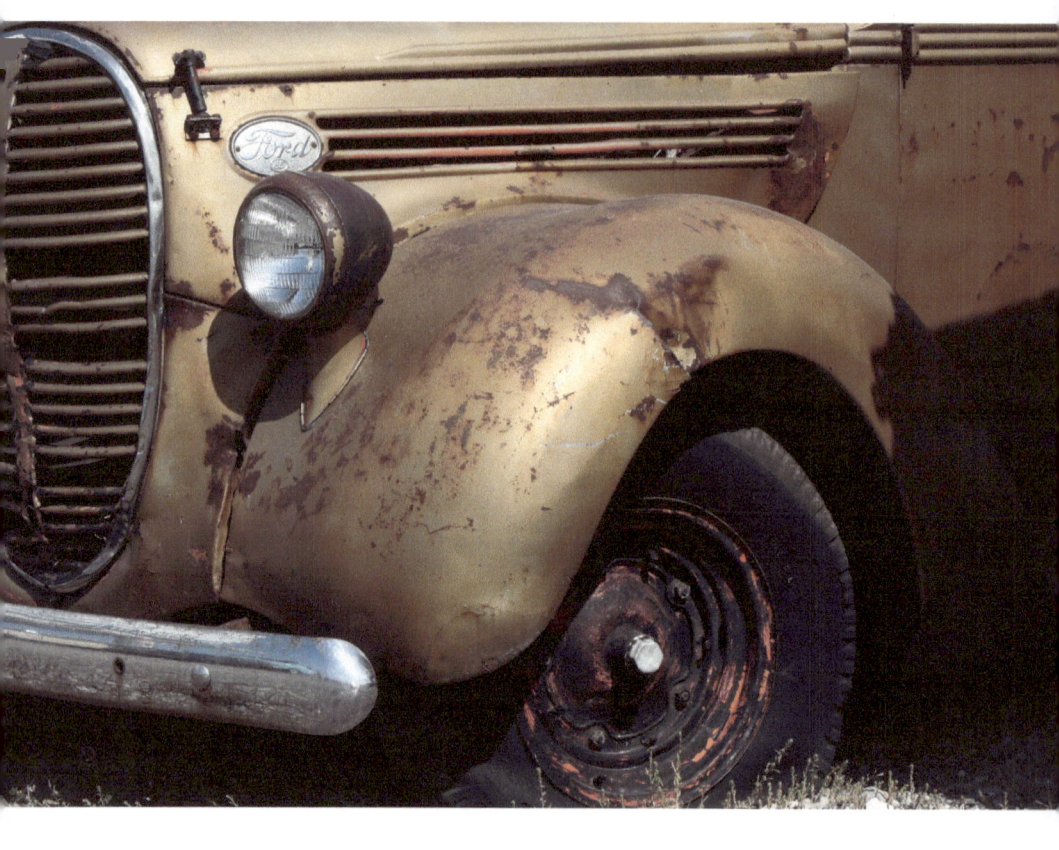

All the noise
and confusion
and running
(and thinking about tooting)
made it look like the rhino's fart
was so big
that it rocketed him
about 25 feet.

The spider monkeys laughed even louder,
and this caused the gibbons to swing over
to see what was going on.

The gibbons told the orangutans
what had happened,
and the orangutans told the gorillas.

The gorillas thought
the whole thing was so funny,
they started throwing poo
at each other.

Once they got started,
they had so much fun
they moved on
to throwing poo
at the people
watching them.

Miss Crunzle's First Grade class
had just made its way
to the gorilla exhibit
when the ruckus broke out.

Miss Crunzle was hit
with gorilla poo
from both sides.

One well-lobbed bit of poo
landed on the top of her hair.

She was stunned.

It was *not* her idea
of being perfectly dressed.

"MARCH!"
she shouted to her kids.
"We're NOT going to watch
the gorillas today."

She marched them
straight to the llama exhibit
so things could be sorted out
and calmed down.

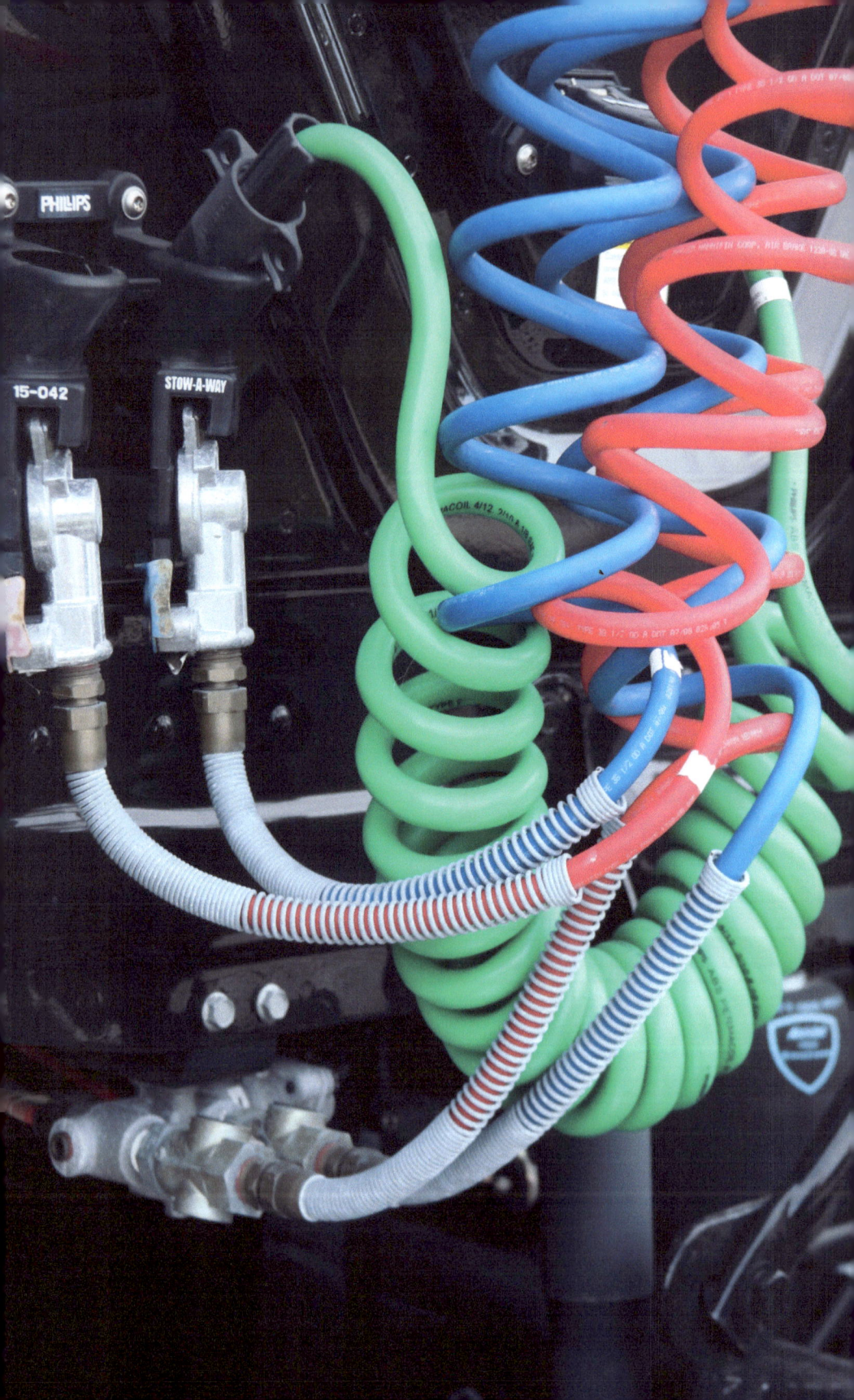

If there's one thing
a llama doesn't like,
it's seeing a tall woman
covered with gorilla poo
coming closer
with 25 first graders.

The llama squinted,
took careful aim,
and spit.

She hit some of the gorilla poo
on Miss Crunzle's blouse
with a clean shot,
if you can call
gooey green spit from a llama
"clean."

The llama spit
mixed with the poo
and made a frightful mess.

Miss Crunzle kept her kids walking
right past the llamas
until they stopped
by the sleeping lion.

Then she stopped to count
and make sure everyone from her class
was still with her
and was properly dressed.

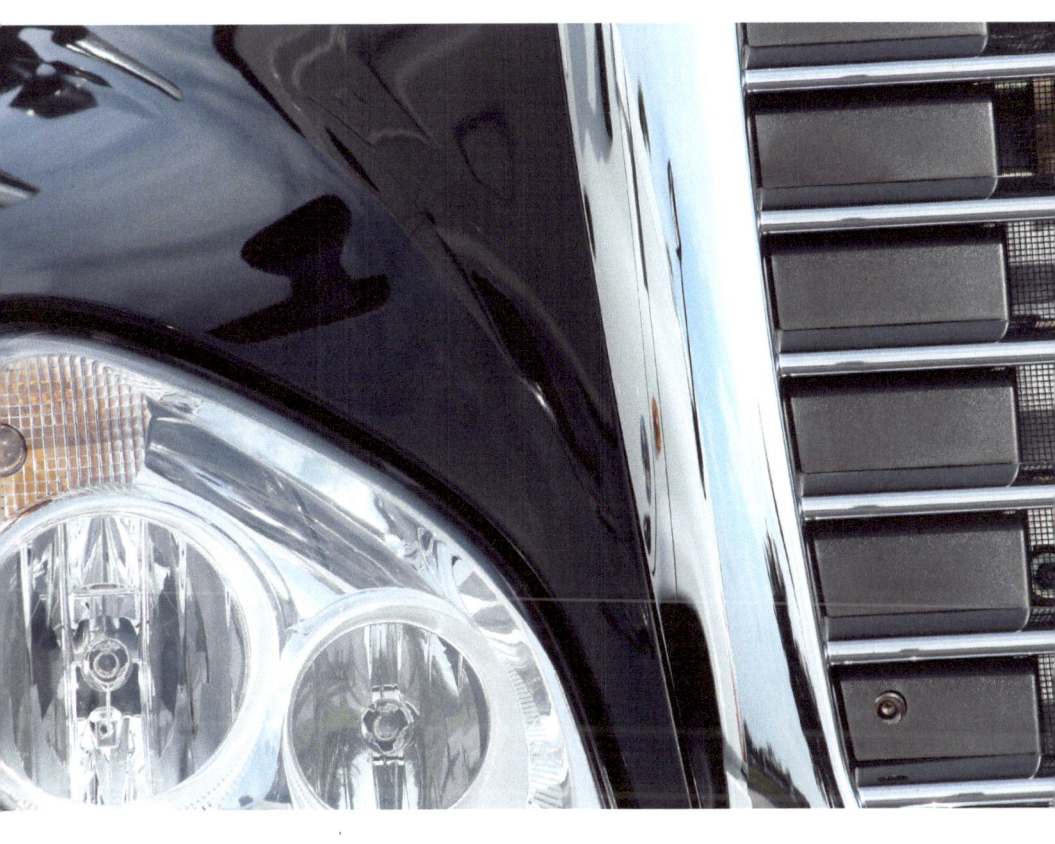

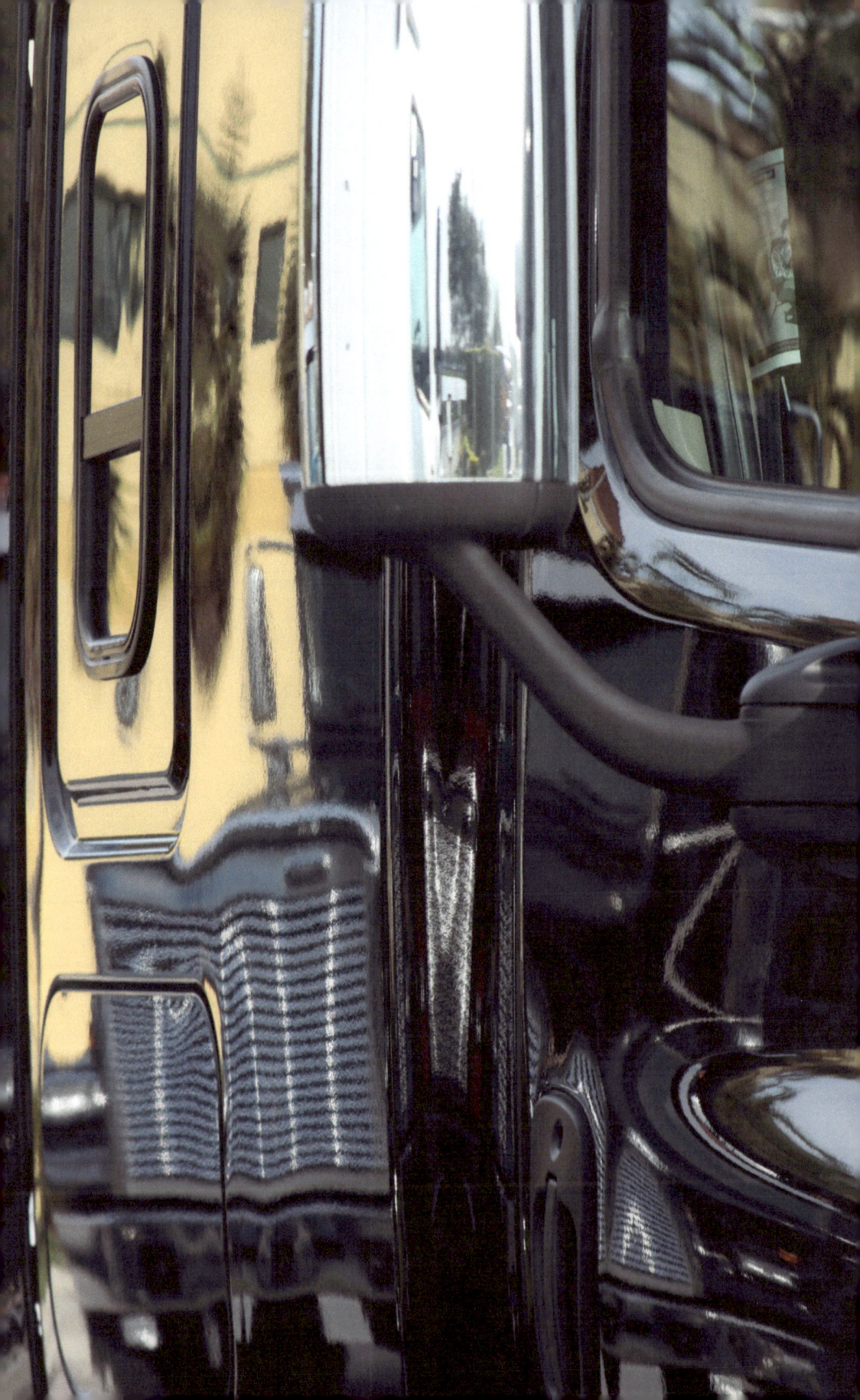

The sleeping lion was having a bad dream
about gorillas and llamas invading his territory.

The excited talk of the school kids
woke him up.

The lion yawned and stretched out his tongue.

The smell of llama spit and gorilla poo
was so thick in the air
it was like the lion could *taste* it.
And if there's one thing a lion doesn't like,
it's tasting gorilla poo and llama spit
after waking up from a long nap.

The lion got up to mark his territory
so the gorillas and llamas
would know to keep their poo and spit
somewhere else.

He decided to start
by spraying the first thing he saw
– Miss Crunzle.

Miss Crunzle
was nearly finished counting
all her kids
when she was hit
with a shot of stinky lion spray.

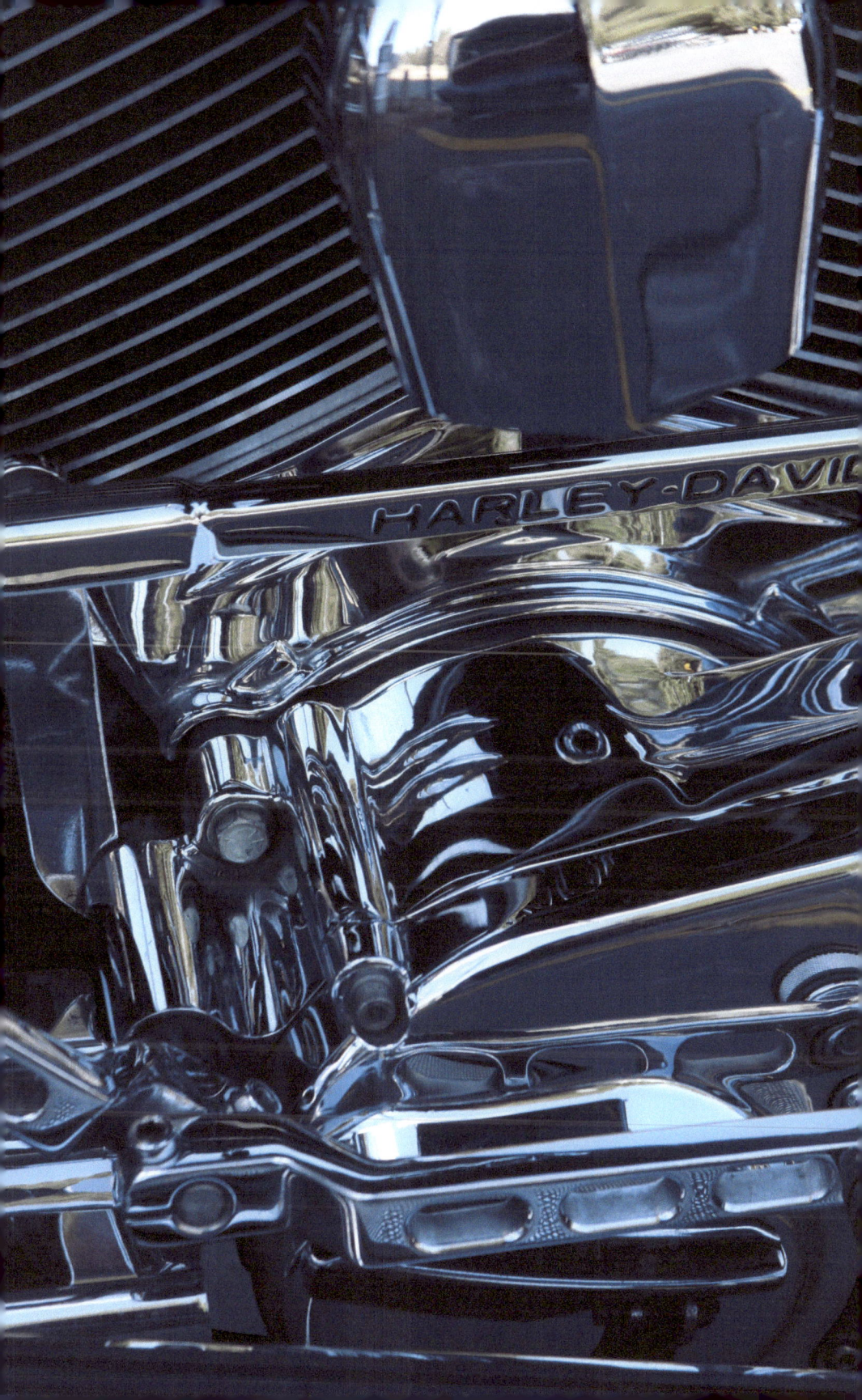

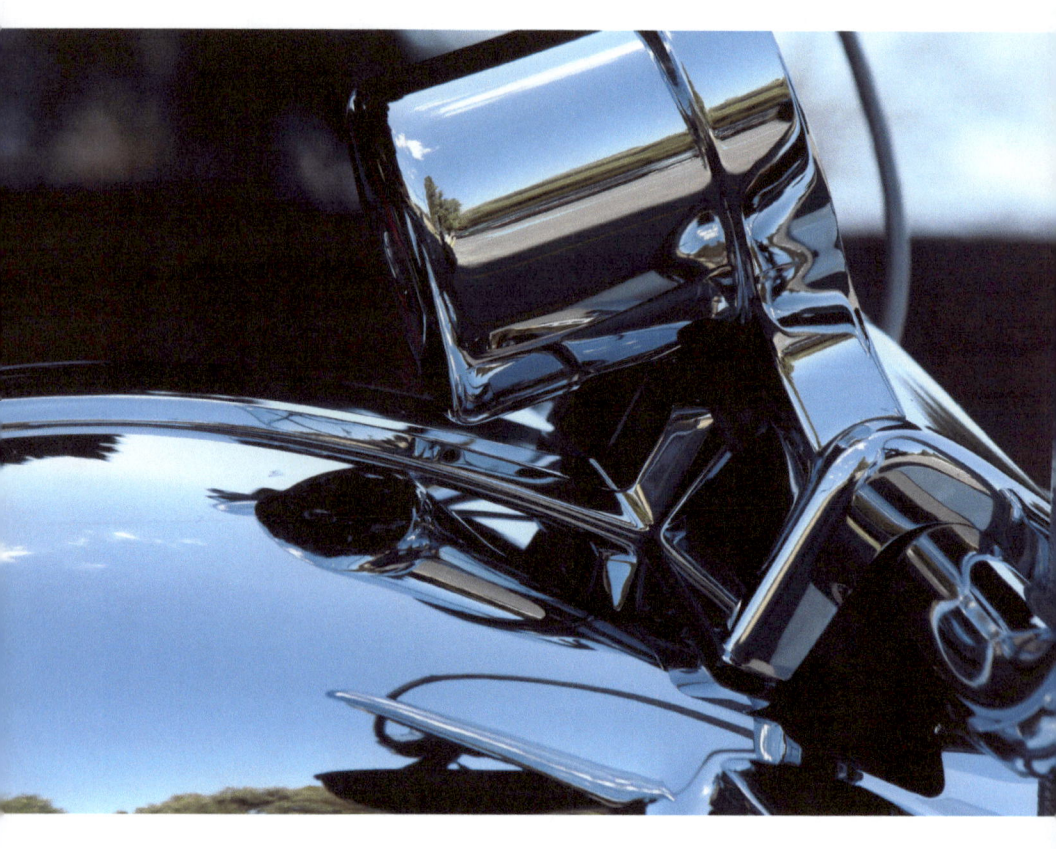

"MARCH!"
she shouted to her kids.

"To the exit. NOW!"

She forgot about showing everyone
the grooming monkeys.

When Miss Crunzle walked past the flamingos,
she smelled so bad from the gorilla poo
and the llama spit
and the lion spray
that all the flamingos farted
at the same time.

The spider monkeys collapsed in laughter.

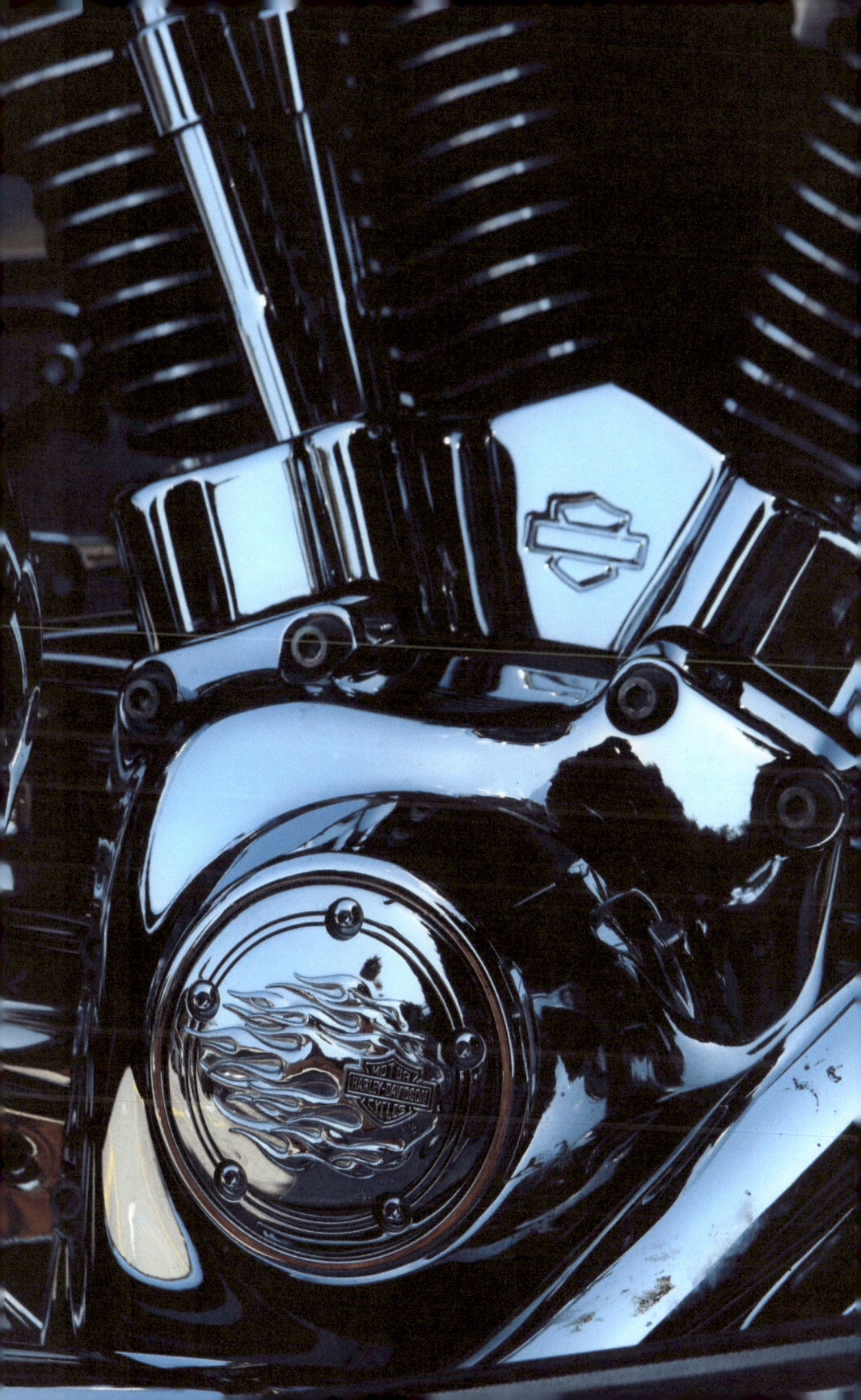

The gibbons told all the other animals
in the zoo what had happened.

None of the animals could stop laughing about it,
and finally the zookeepers gave up
and sent all the animals to bed.

The zookeepers told visitors
arriving that afternoon
that the animals
couldn't be seen that day
because of the cold weather.

But really it was because
the ostrich farted.

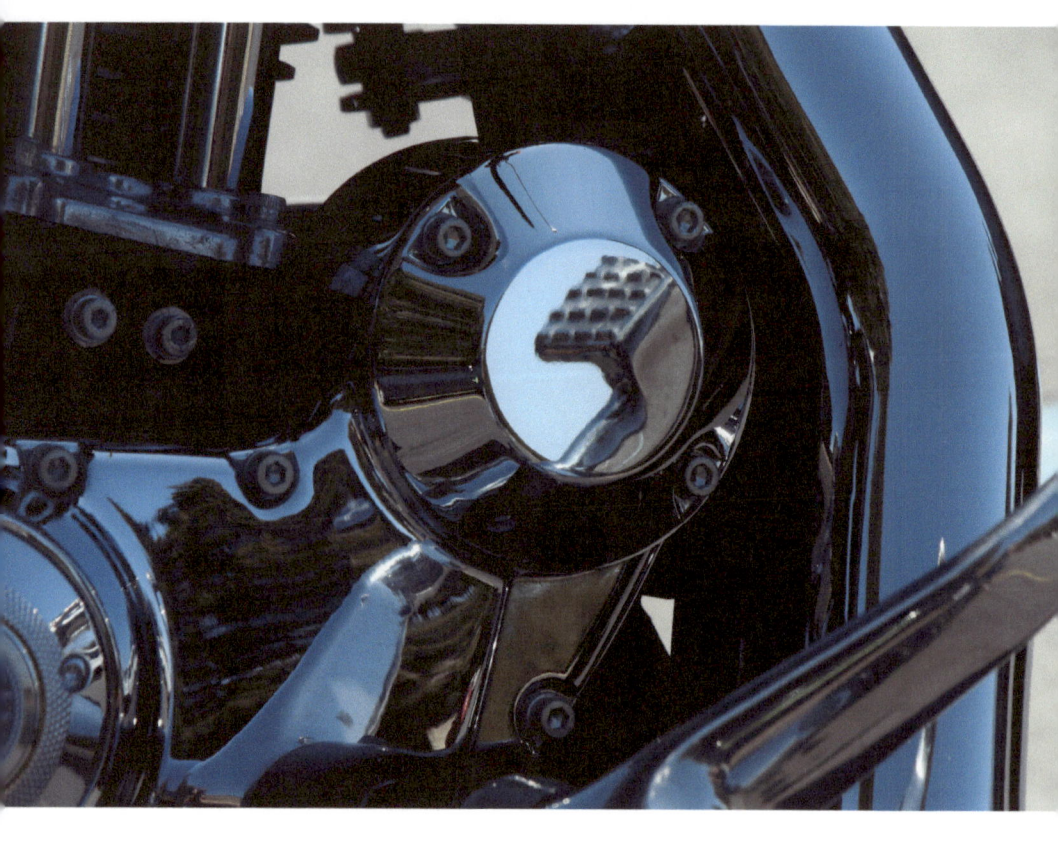

The next time Jim arrived at school
with his t-shirt not tucked in,
Miss Crunzle didn't say a word.

~ ~ ~

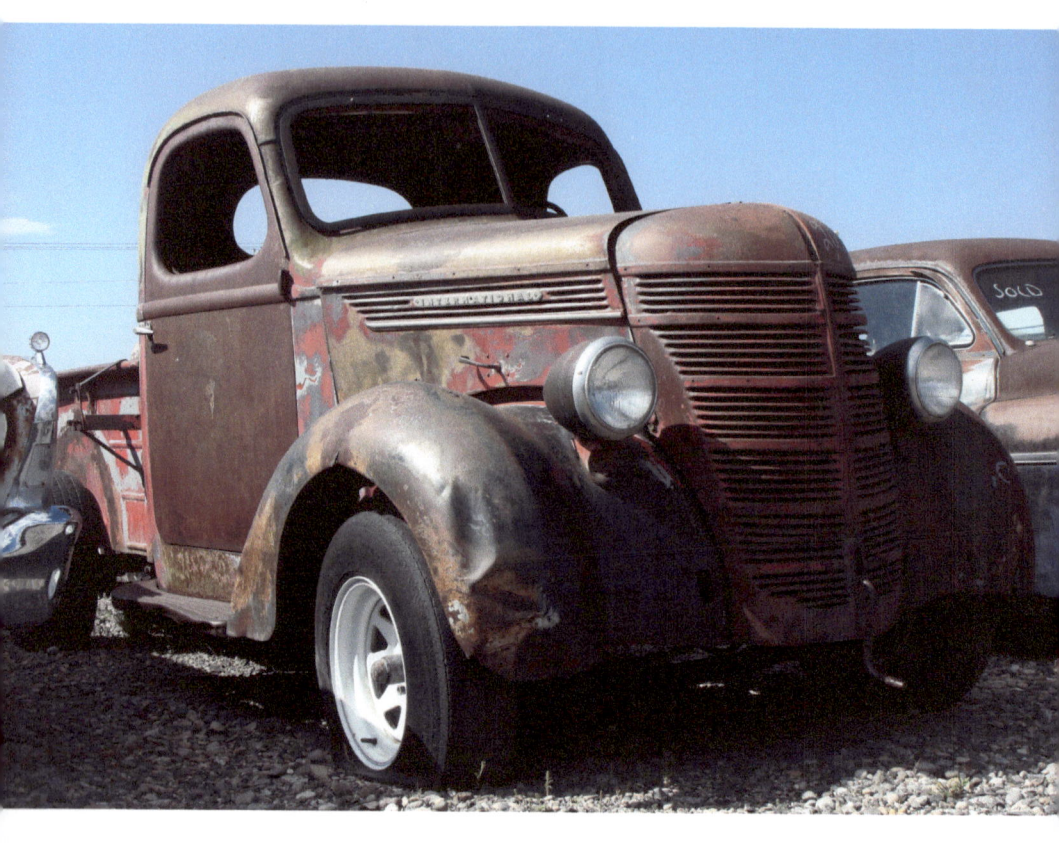

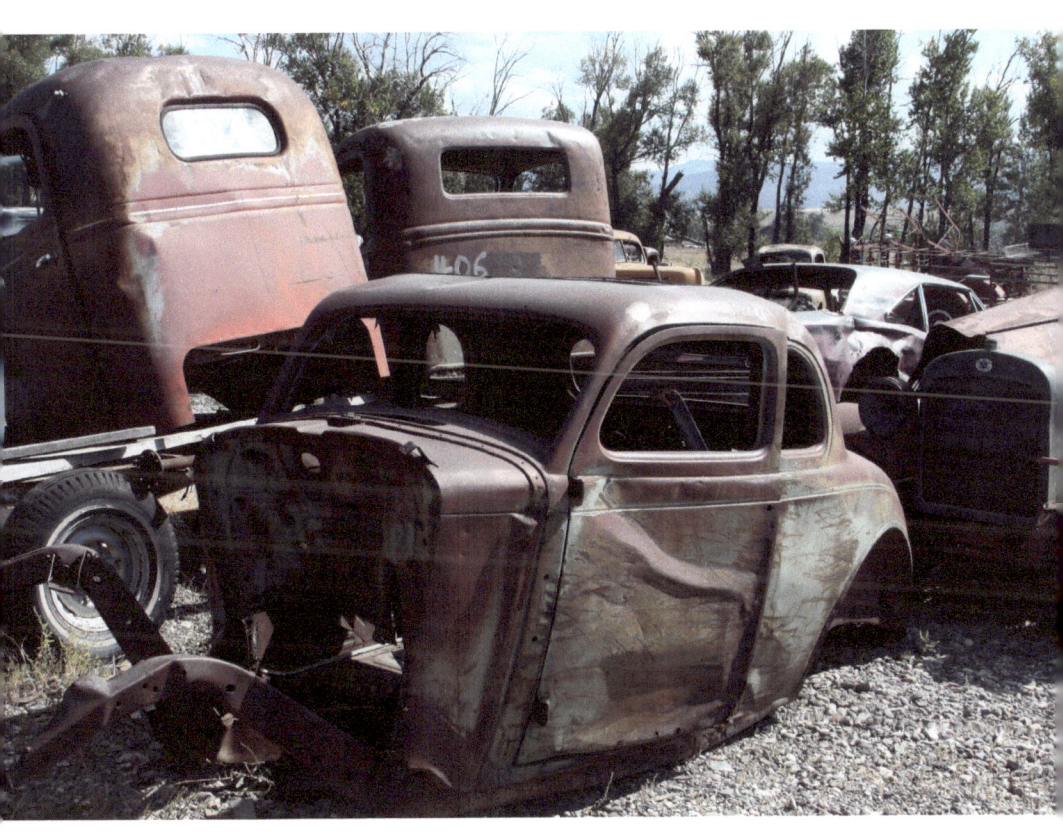

This Mark Dahle Portfolio includes a gorgeous abstract painting, twenty-five beautiful photographs of construction in Basel, Switzerland, and a story about a group of trolls moving to Norway.

When the trolls moved, they had to pass through a large forest. The trees and the trolls kept bumping into each other. It was no fault of the trees.

A Mark Dahle Portfolio

When The Trolls Moved

A Mark Portfolio

The Boy Who Loved Monopoly

This Mark Dahle Portfolio includes a colorful painting, twenty-seven beautiful photographs of Venice, and a story about a boy who loved to play Monopoly. One day the boy received $250,000 as an inheritance.

> You probably haven't inherited any money this week.
> But you've got lots of gifts
> and lots of things that you're good at —
> or could be, after you get more practice.
> What will *you* do with all the gifts that *you* have?

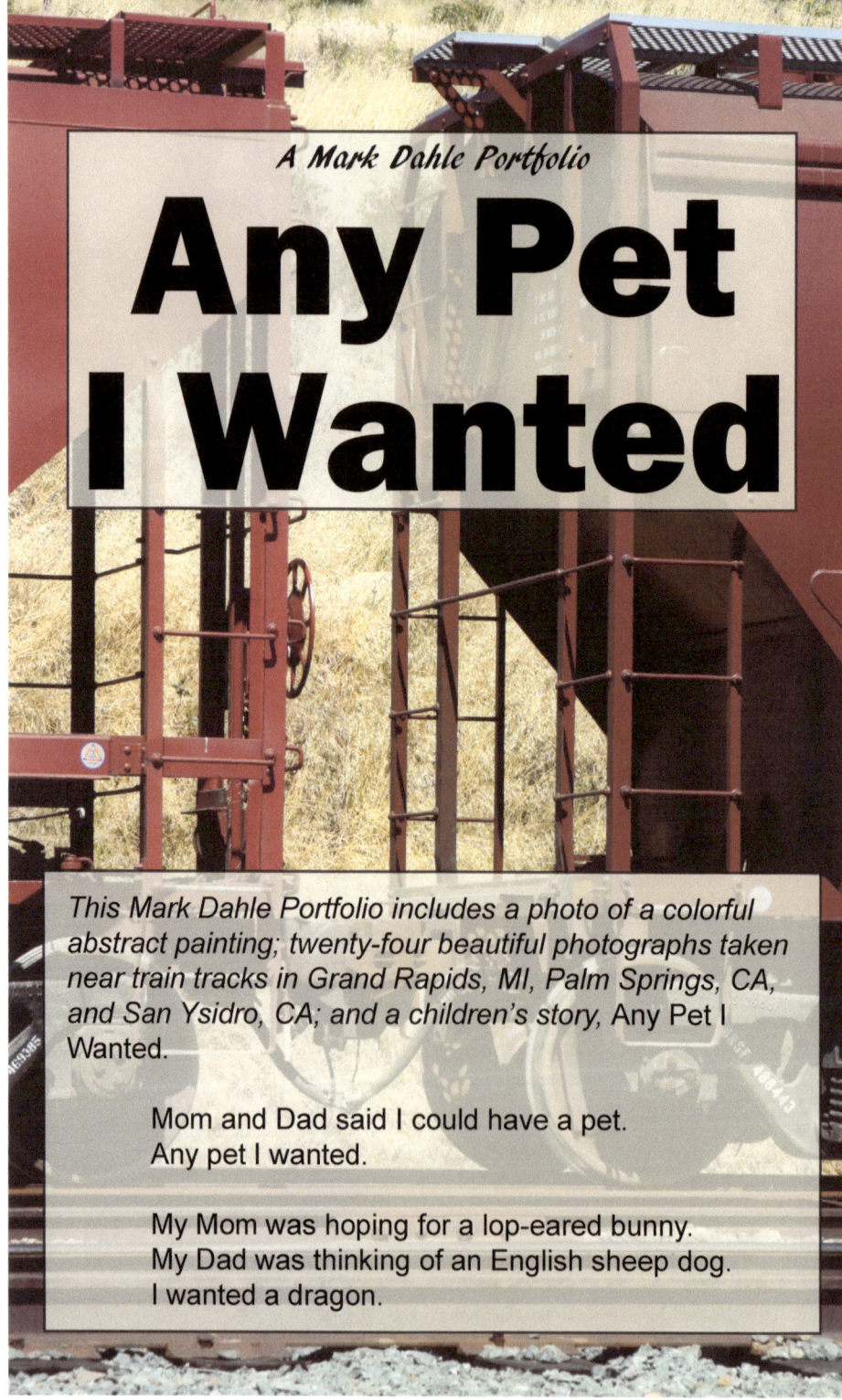

A Mark Dahle Portfolio

Any Pet I Wanted

This Mark Dahle Portfolio includes a photo of a colorful abstract painting; twenty-four beautiful photographs taken near train tracks in Grand Rapids, MI, Palm Springs, CA, and San Ysidro, CA; and a children's story, Any Pet I Wanted.

 Mom and Dad said I could have a pet.
 Any pet I wanted.

 My Mom was hoping for a lop-eared bunny.
 My Dad was thinking of an English sheep dog.
 I wanted a dragon.

www.ingramcontent.com/pod-product-compliance
Lightning Source LLC
Chambersburg PA
CBHW041109180526
45172CB00001B/175